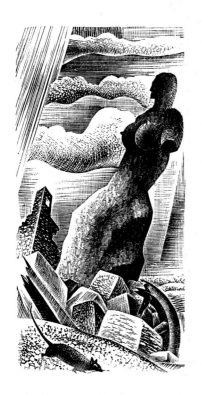

Prelude to a Million Years

&

Song Without Words

TWO GRAPHIC NOVELS

LYND WARD

With a New Introduction by
DAVID A. BERONÄ

Dover Publications, Inc., Mineola, New York

Copyright

Bibliographical Note

This Dover edition, first published in 2010, is a new compilation, unabridged, of the following works by Lynd Ward: *Prelude to a Million Years: A Book of Wood Engravings by Lynd Ward*, originally published by Equinox Cooperative Press, Inc., New York, in 1933, and *Song Without Words: A Book of Engravings on Wood by Lynd Ward*, originally published by Random House, New York, in 1936. An introduction by David A. Beronä has been specially prepared for the Dover edition.

Library of Congress Cataloging-in-Publication Data

Ward, Lynd, 1905–1985.
 [Prelude to a million years]
 Prelude to a million years and Song without words: two graphic novels / Lynd Ward ; with a new introduction by David A. Beronä — Dover ed.
 p. cm.
 Added t.p. title: Song without words
 First work originally published: Prelude to a million years. New York : Equinox Cooperative Press, 1933; 2nd work originally published: Song without words. New York : Random House, 1936. With new introd.
 ISBN-13: 978-0-486-47269-0
 ISBN-10: 0-486-47269-8
 1. Stories without words. 2. Graphic novels—United States. I. Ward, Lynd, 1905–1985. Song without words. 2010. II. Title. III. Title: Song without words.

NE1112.W37A4 2010
769.92—dc22

2009042827

Manufactured in the United States by Courier Corporation
47269801
www.doverpublications.com

Introduction

David A. Beronä

After the publication of Lynd Ward's third woodcut novel, *Wild Pilgrimage* (1932), he completed two shorter "pictorial narratives"— his preferred description of his graphic novels. These shorter works were *Prelude to a Million Years* (1933), which addressed the social and spiritual isolation of an artist, and *Song Without Words* (1936), which centered on a mother's haunting fears of bringing a child into a hopeless world. These two works display Ward's remarkable skill as a wood engraver whose precise lines, intricate detail, and astonishing balance of light and shadow create a tension—sometimes unsettling— in each unfolding drama.

Prelude to a Million Years

Prelude to a Million Years, with thirty wood engravings, was printed from the original blocks in a limited edition of 920 copies. It was the third book published by Equinox Cooperative Press, a publishing company conceived by Ward to bring the best names in book production together and revive the craftsmanship of bookmaking. The nine founding members of this cooperative included the printer Lewis F. White; the graphic artists Albert Heckman, John P. Heins, and Ward; publishing and business trade professionals Belle Rosenbaum, Evelyn Harter, Henry Hart, Mabel Remont; and May McNeer, Ward's wife, who was a noted children's book author.

Henry Hart, in *A Relevant Memoir: The Story of the Equinox Cooperative Press* (1977), stated that Equinox, the publisher of sixteen books from 1932 to 1937, "unlike most idealistic publishing ventures, made money and ended with all its members still being friends." *Prelude for a Million Years* was a financial success and provided needed revenue that supported ongoing Equinox projects. Lynd Ward also supplied wood engravings for Llewelyn Powys' *Now That the Gods Are Dead* (1932) and lithographs for Thomas Mann's *Nocturnes* (1934) and Granville Hicks's *One of Us: The Story of John Reed* (1935). Of particular interest, as Ward wrote in his Introduction to Hart's memoir, was the fact that their cooperative was recognized as

iii

a producer cooperative, similar to a farm, and became "the only publishers in the history of the Western culture who had to file annual reports with the New York State Department of Agriculture." Amazingly, this new business had formed during the depths of the economic Depression. It dissolved on December 9, 1939, with the inevitability of a world war, as well as its members' growing outside obligations. During this time, Ward's work as a book illustrator increased. He illustrated Harry F. Ward's *In Place of Profit: Social Incentives in the Soviet Union* (1933), Myron Brinig's *The Flutter of an Eyelid* (1933), Marjorie Medary's *Topgallant: A Herring Gull* (1935), and a stunning edition of Mary Wollstonecraft Shelley's *Frankenstein* (1934), which contained some of Ward's more inspiring wood engravings; it has been reprinted under the title *Frankenstein: The Lynd Ward Illustrated Edition* in 2009 by Dover Publications.

Prelude to a Million Years examines the theme of living for the sake of art in a world of social turmoil. Ward placed his artist—in this story a sculptor working on an idealized sculpture of a woman—against a backdrop of urban unrest during the Depression era. Ward considered the insular isolation of a sculptor in contrast to his forsaken personal life and the social disturbances he experiences on the street, including striking workers and angry patriotic demonstrators. In this short series of prints, objects hold symbolic importance, such as a spider's web that indicates the passage of time, or a street hydrant that depicts the incendiary emotions of a labor riot.

One of Ward's consistent images in his pictorial narratives is a flower that symbolizes beauty. The opening dreamlike sequence displays a scene where the sculptor kneels in veneration to artistic beauty, exemplified by an exotic flower. In contrast to this scene, Ward presents the sculptor in reality, and how his artistic pursuit has isolated him. Before leaving his apartment to find a forsaken lover, the sculptor gazes down on a flower in a vase. His focus is on the flower and not his neighbor, who is being beaten by her husband. In this example, the sculptor's attachment to his artistic quest betrays his indifference to human suffering and personal involvement.

During my early research on Ward, I had the privilege of interviewing many of his family members and friends, such as the preeminent wood engraver John DePol, who was recognized as an American treasure in the print world. In a phone interview, DePol had the highest praise for Ward's work and regarded his extensive output as "energetic." DePol further indicated in a letter, included in the Lynd Ward and May McNeer Papers collection at Georgetown University, that of all of Ward's six woodcut novels, *Prelude to a Million Years* was his

favorite. Reviewers, at the time, however, such as E. L. Tinker of *Books*, criticized the repetition in Ward's woodcut novels of plot elements, as well as the main character's recurring "revolt against the injustices of society, his preoccupation with sex, his self-loathing after he has succumbed to the scarlet woman, and his final disillusionment," but he praised Ward's skill as a wood engraver and "the complete mastery he has acquired over his medium."

Song Without Words

Lewis F. White, a founding member of Equinox, printed *Song Without Words* with twenty-one wood engravings directly from the blocks in a limited edition of 1,250 copies for Random House. This book centers on a mother's fear of bringing a child into a cataclysmic world. Ward includes vermin and scavengers such as rats, vultures, and ants to express the mother's growing fears. As in his previous woodcut novels, Ward uses standard symbols—looming city buildings and caricatures of military officers and devious financiers who profit from the defenseless. These disturbing and impassioned engravings included a disconcerting image of ants crawling over the skin of a baby impaled on a bayonet, as well as a swastika displayed above an encampment with starving children, supporting rising suspicions, at that time, of the existence of Nazi concentration camps in Europe. Ward concludes this visually disturbing, harrowing story with an uplifting assertion of faith and trust in family.

This book not only displayed Ward's growing concern with Fascism but also reflected a personal decision that he and McNeer made involving their second child, Robin, who was born in 1937. The first time that I visited Robin and her husband, Michael, at their home in Virginia, I noticed one wall filled with prints from *Song Without Words*. Robin saw my interest and told me that *Song Without Words* was her birthright—that she would not have been born if her parents had not worked through their fears, which Ward depicted in this book.

I also uncovered in Ward's papers at Georgetown University a short series of proofs titled *Hymn for the Night*. This incomplete narrative of eighteen wood engravings depicts the bible story of Mary and Joseph seeking shelter. Rather than the traditional setting of Bethlehem, Ward placed the couple inside a Nazi-occupied city where Mary and Joseph hid in the shadows as they passed Nazi soldiers burning books and beating people on the streets. Soldiers eventually captured Joseph, but Mary escaped and found shelter before giving birth to the Christian Messiah. The ominous style of these prints

reflects the tone and themes from *Song Without Words*; George Barringer, the Special Collections librarian at that time, placed this work between 1935 and 1945.

By the end of the 1930s, Ward devoted his time to book illustration and printmaking. He served as the director of the graphic arts division of the Federal Writers Project in New York City from 1937 to 1939. His illustrations for the multi-volume edition of *Les Misérables* (1938) inaugurated a series of classics that Ward produced for George Macy's Limited Editions Club and the trade publication offshoot, Heritage Press. The market for children's book illustrations grew steadily, whereas the adult market for wordless books had all but evaporated by the end of the decade. Although Ward never published another woodcut novel following *Vertigo* in 1937, he did publish a wordless children's book with 80 casein drawings called *The Silver Pony: A Story in Pictures* (1973), which remains in print today.

Ward was aware that every reader brought an entirely different set of experiences to his pictorial narratives, influencing their interpretation of each book. When both of Ward's daughters, Robin and her older sister, Nanda, grew up, they recalled that whenever they asked their father what he meant by a certain passage in one of his woodcut novels, he always replied the same way, to them and to anyone else who asked: "It is not what I intended," Ward would say. "It is what you see in it yourself that matters."

I discovered, after re-reading these two books, that my understanding of the stories has changed following personal passages in my life over the years. Ward's celebrated skill as an artist is evident in his striking wood engravings, but what became even more apparent was Ward's unique ability to tap into our deepest psychological fears and desires with a powerful visual language that speaks distinctly to each one of us in a different way throughout our lives.

David A. Beronä is a woodcut-novel historian, author of *Wordless Books: The Original Graphic Novels* (2008) and a 2009 Harvey Awards nominee. He is the Dean of the Library and Academic Support Services at Plymouth State University, New Hampshire, and a member of the visiting faculty at the Center for Cartoon Studies, White River Junction, Vermont.

Prelude to a Million Years

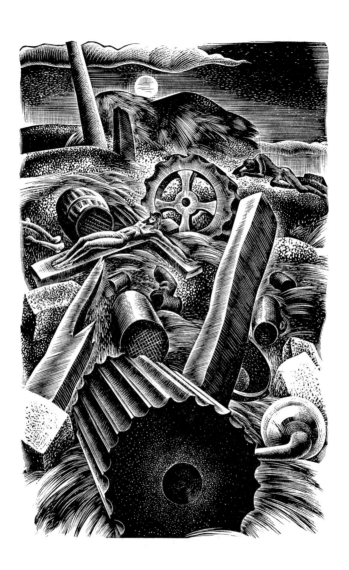

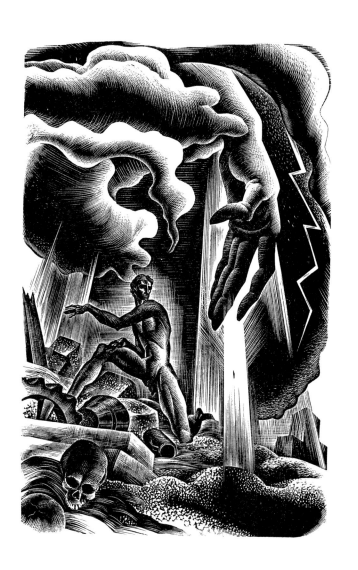

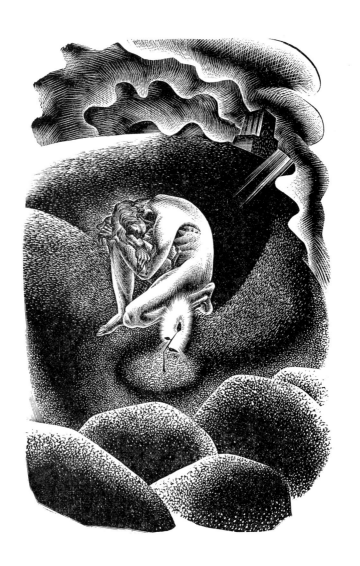

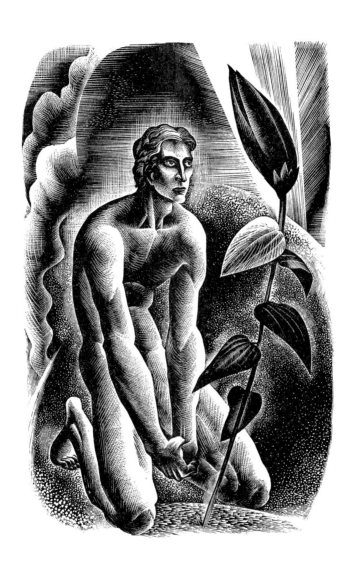

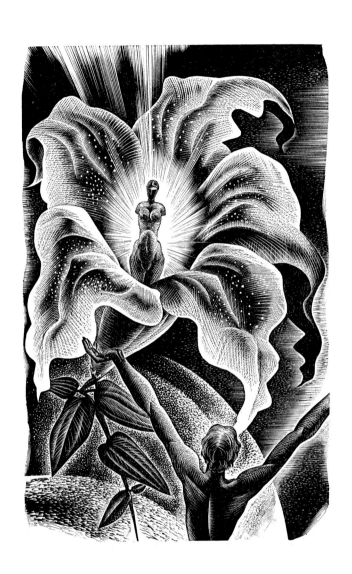

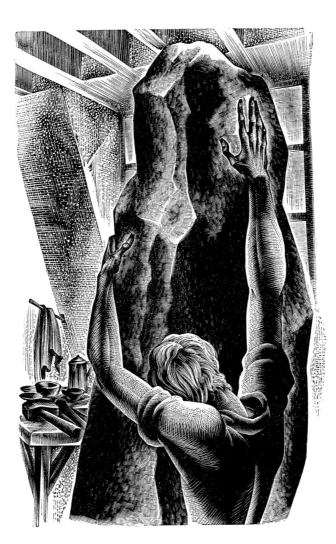

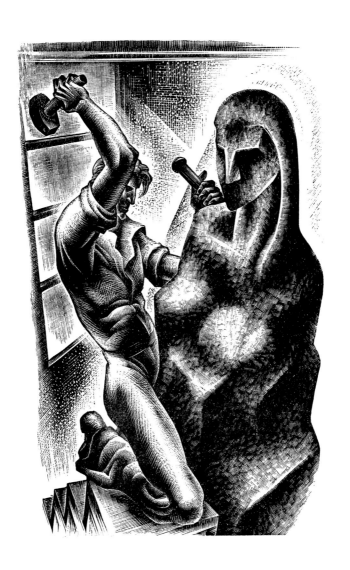

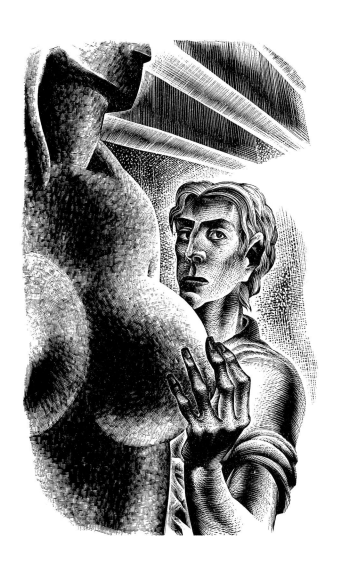

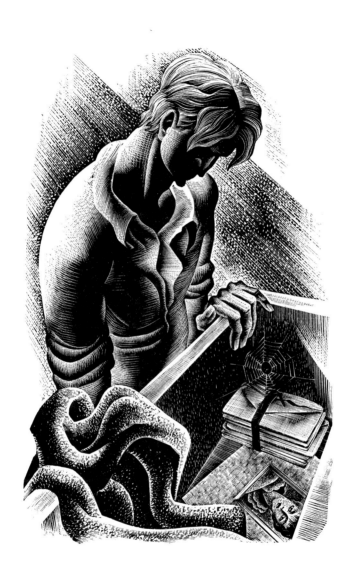

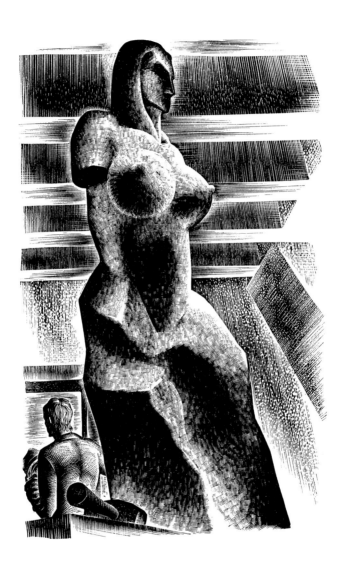

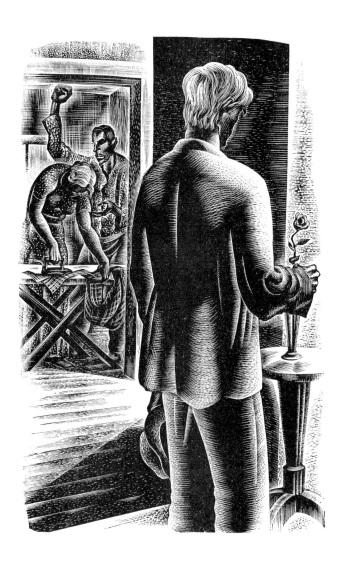

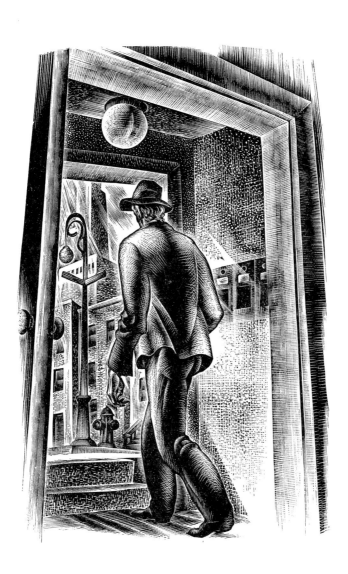

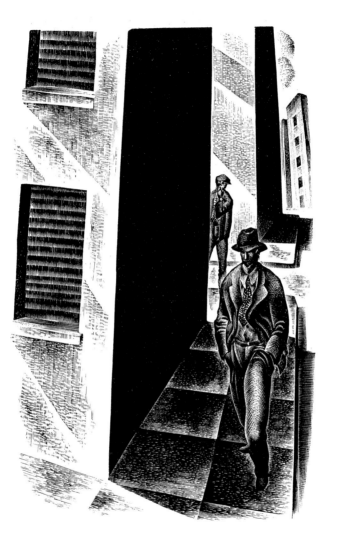

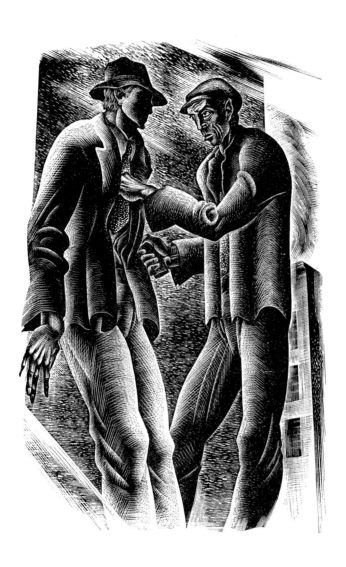

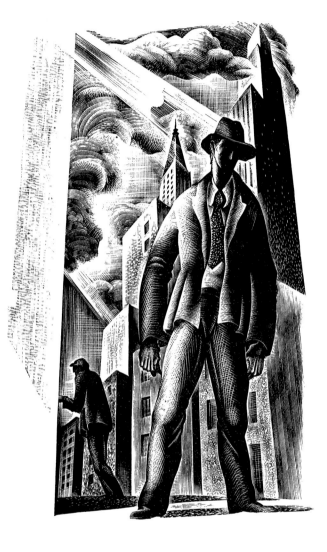

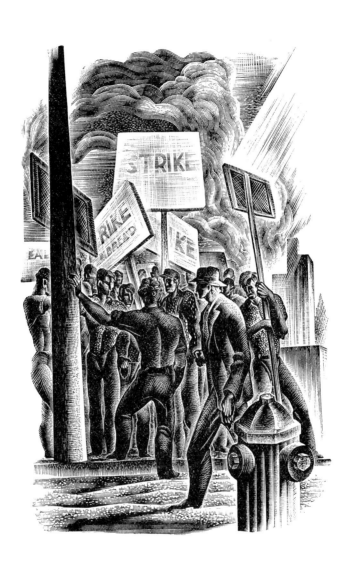

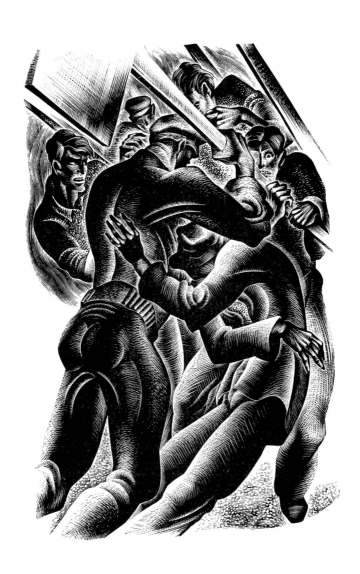

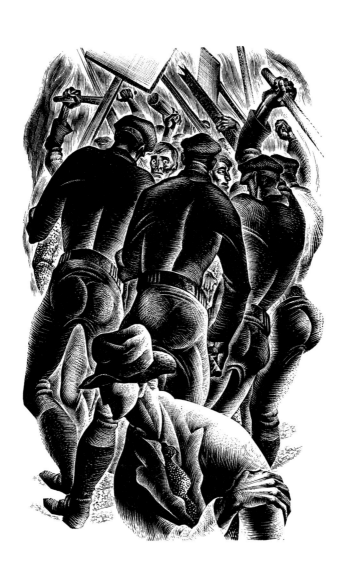

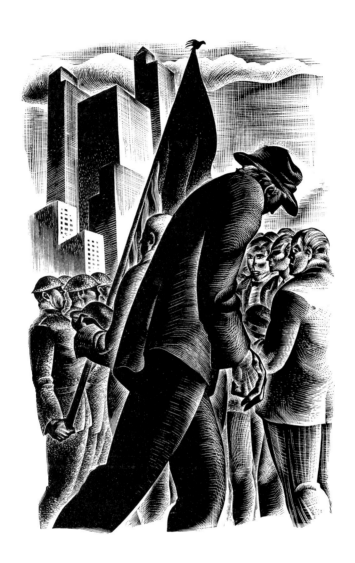

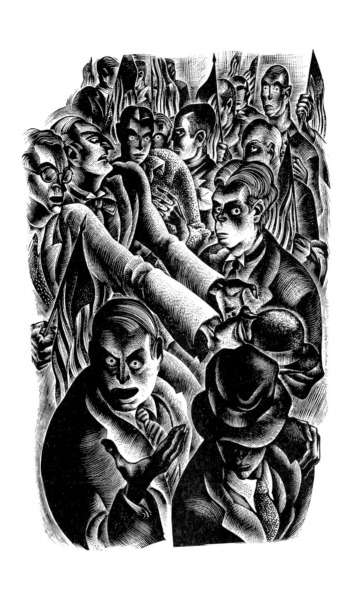

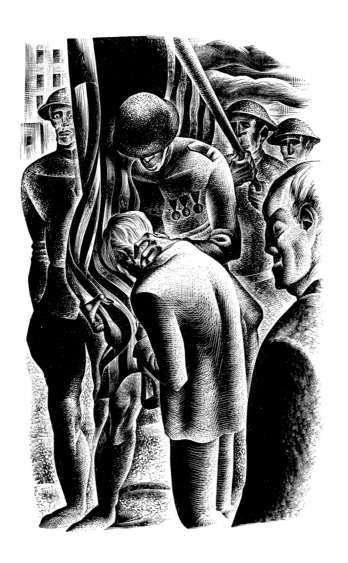

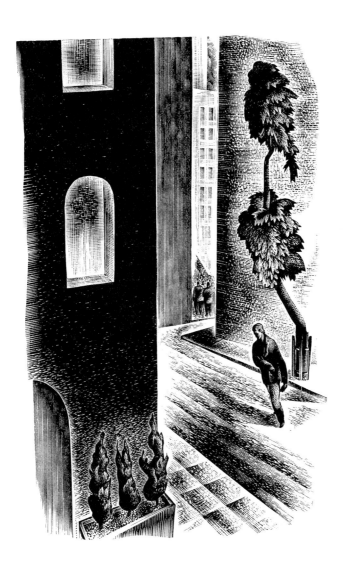

.

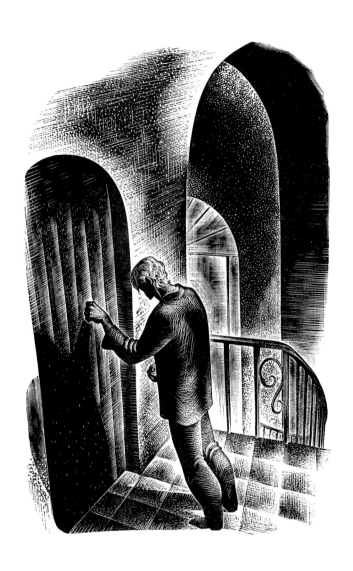

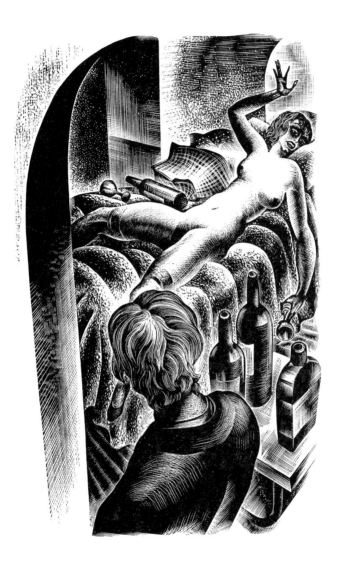

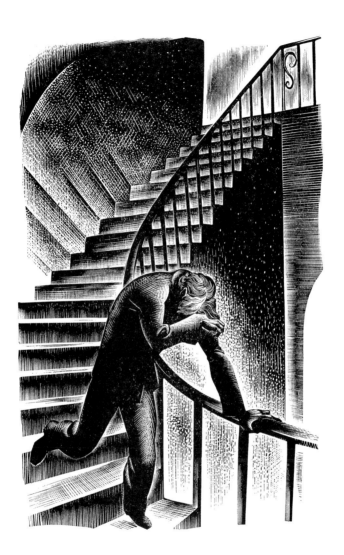

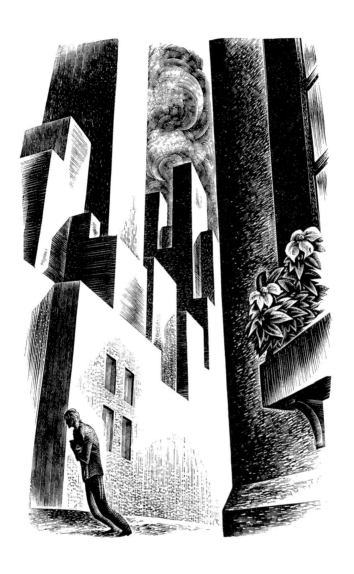

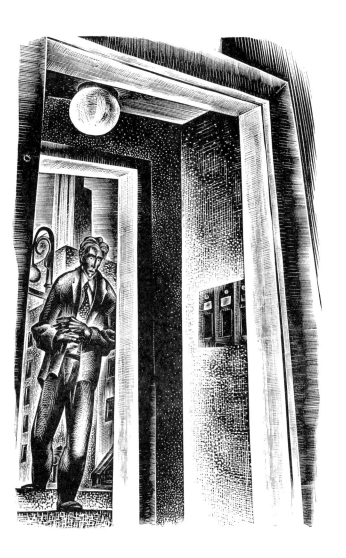

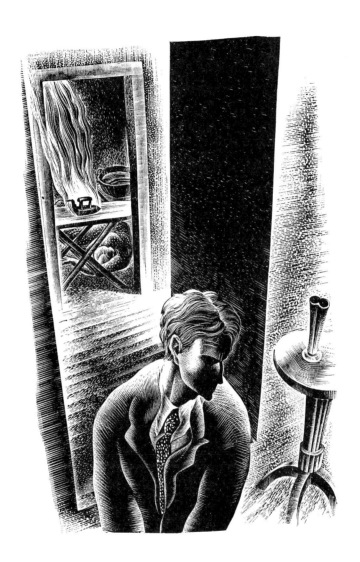

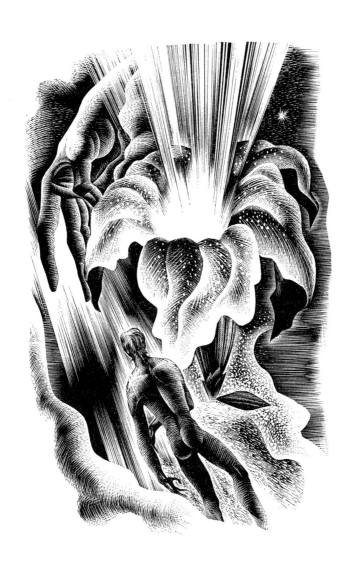

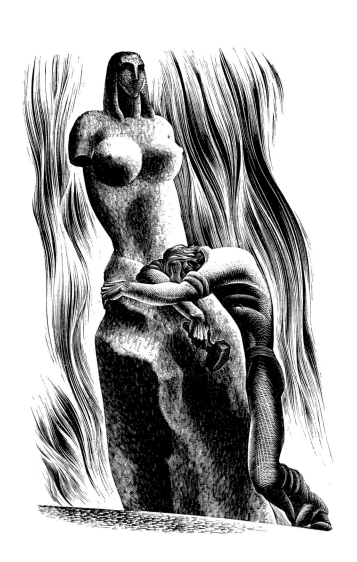

Song Without Words

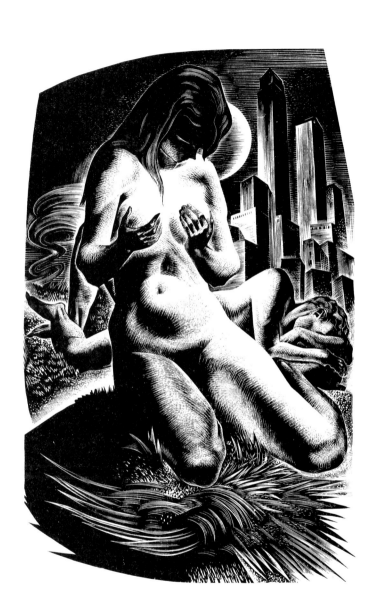

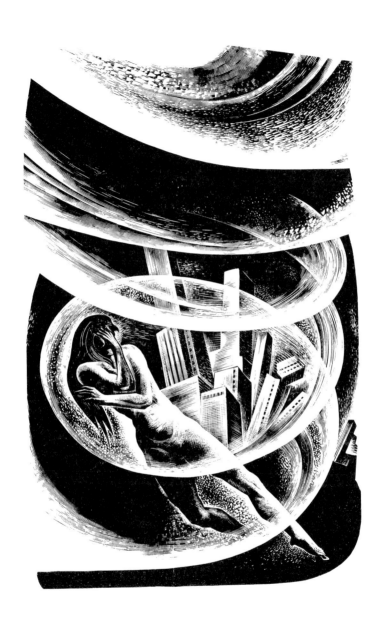

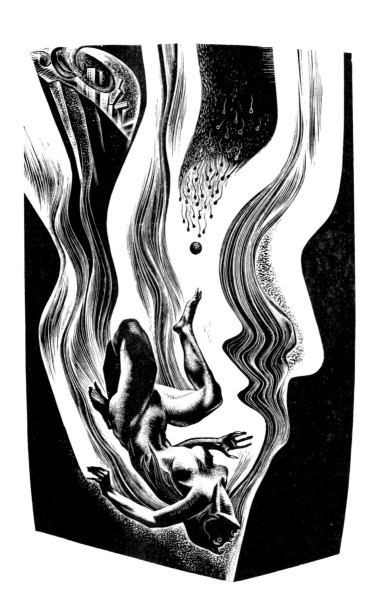

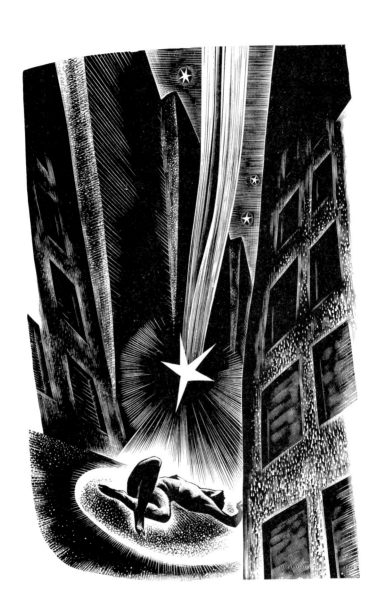

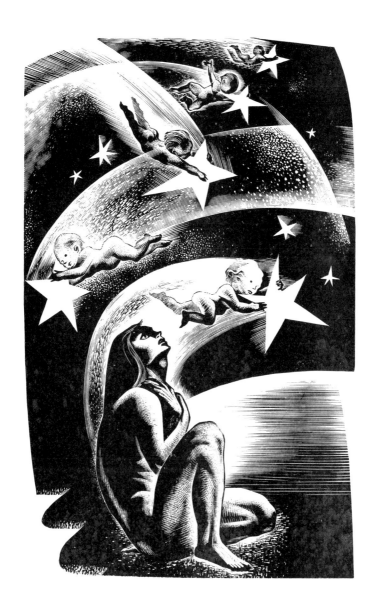

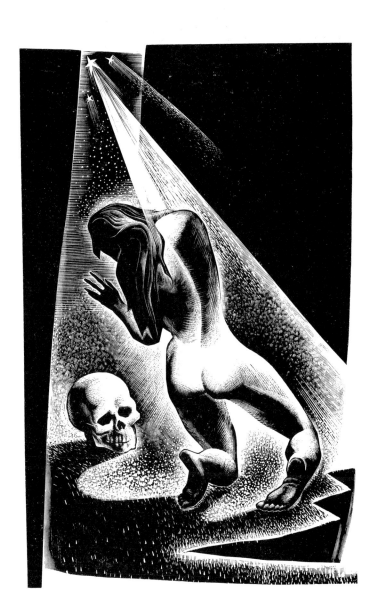

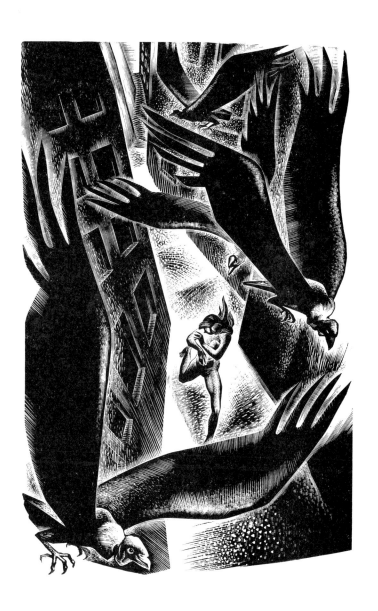

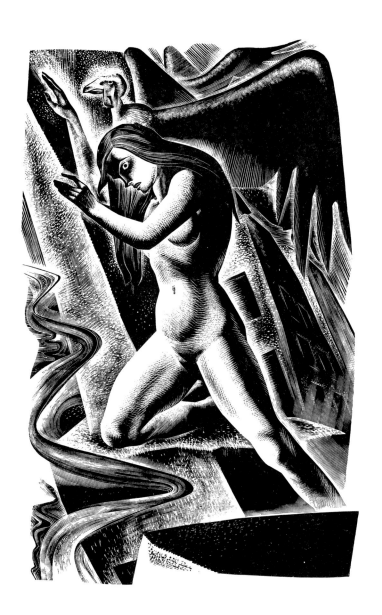

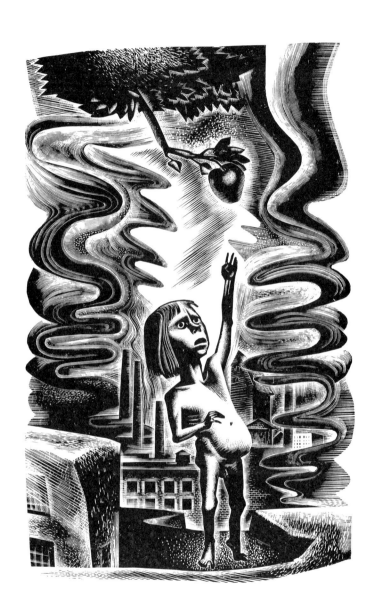

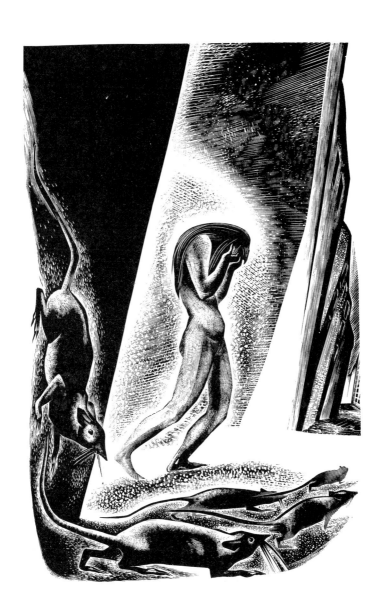

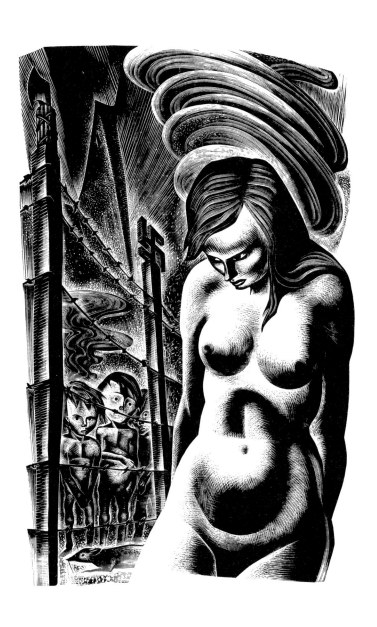

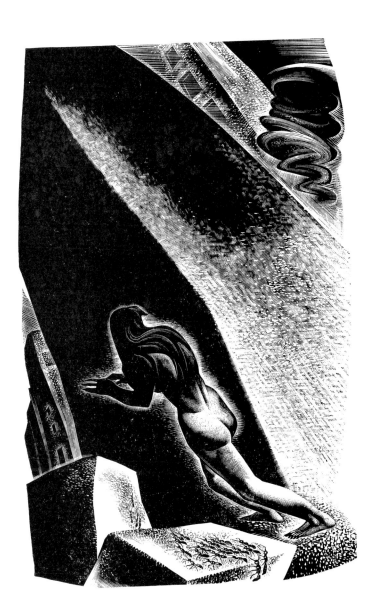

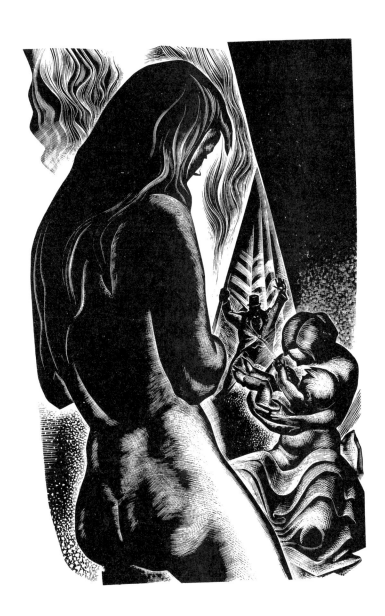

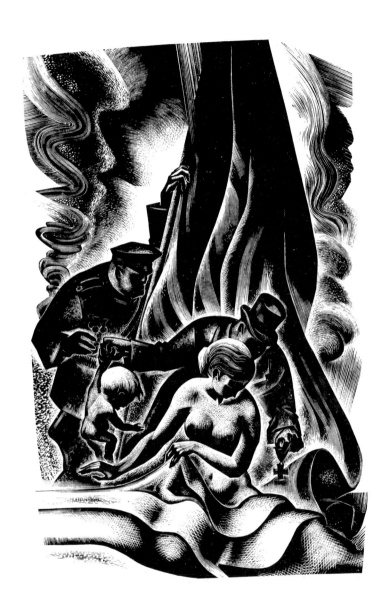

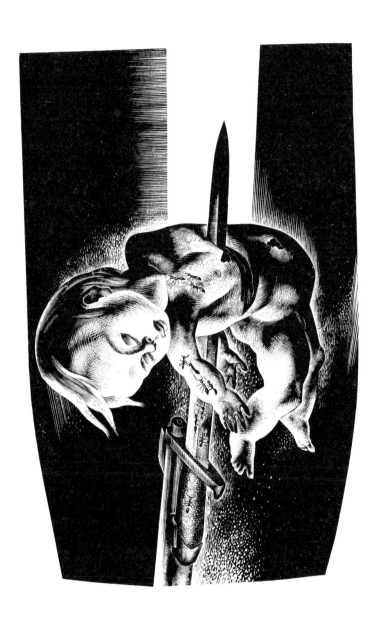

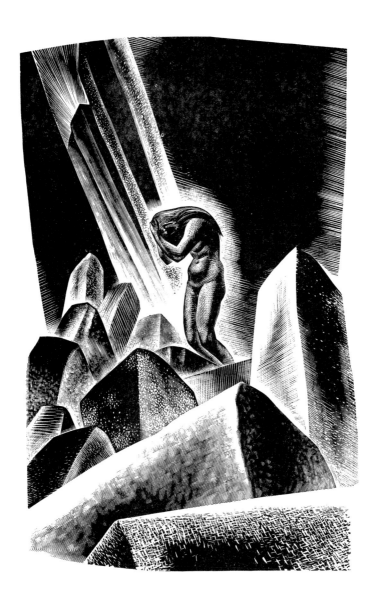

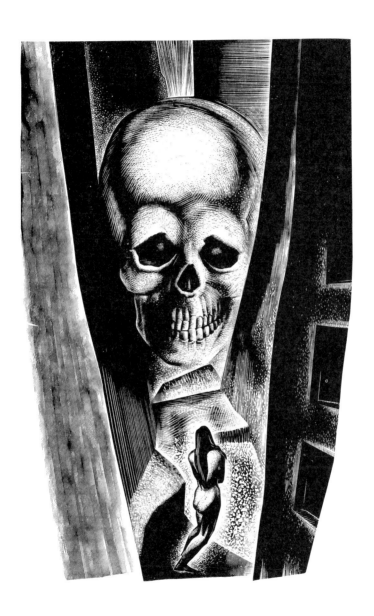

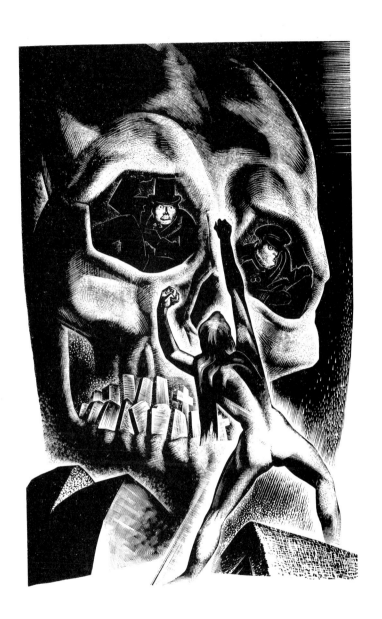

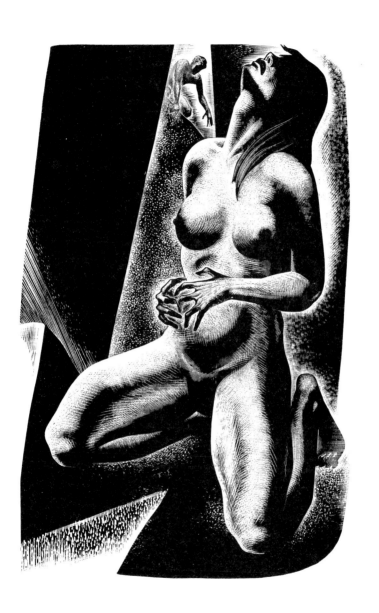

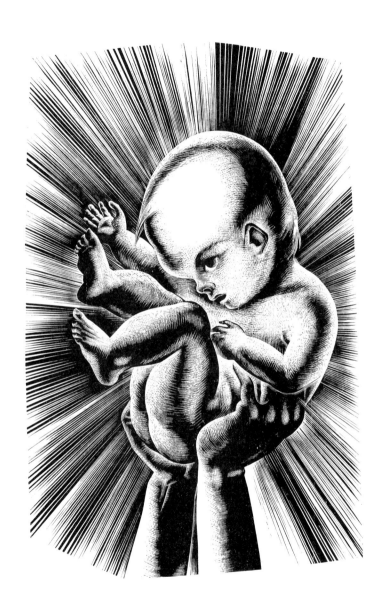

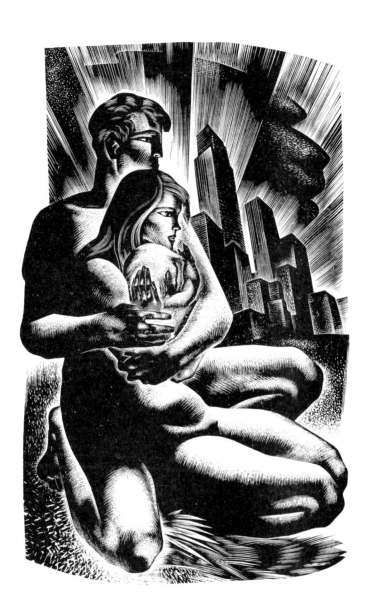